CONSERVATION OF PAINTINGS

David Bomford

NATIONAL GALLERY PUBLICATIONS LONDON

DISTRIBUTED BY YALE UNIVERSITY PRESS

This publication is supported by
The Robert Gavron Charitable Trust

THE POCKET GUIDES SERIES

OTHER TITLES

Allegory, Erika Langmuir
Frames, Nicholas Penny
Landscapes, Erika Langmuir

FORTHCOMING TITLES

Colour, David Bomford and Ashok Roy
Faces, Alexander Sturgis

Front cover and title page:
Sassoferrato, *The Virgin and Child Embracing*, details of 48.

First published in Great Britain in 1997 by
National Gallery Publications Limited
5/6 Pall Mall East, London SW1Y 5BA

ISBN 1 85709 164 7

525238

British Library Cataloguing-in-Publication Data
A catalogue record is available from the British Library
Library of Congress Catalog Card Number: 97-67665

Edited by Felicity Luard and Nicola Coldstream
Designed by Gillian Greenwood
Printed and bound in Great Britain by Ashdown Press Limited, London

CONTENTS

FOREWORD

The National Gallery contains one of the finest collections of European paintings in the world. Open every day free of charge, it is visited each year by millions of people.

We hang the collection by date, to allow those visitors an experience which is virtually unique: they can walk through the story of Western painting as it developed across the whole of Europe from the beginning of the Renaissance to the end of the nineteenth century – from Giotto to Cézanne – and their walk will be mostly among masterpieces.

But if that is a story only the National Gallery can tell, it is by no means the only story. The purpose of this new series of *Pocket Guides* is to explore some of the others – to re-hang the Collection, so to speak, and to allow the reader to take it home in a number of different shapes, and to follow different narratives and themes.

Hanging on the wall, for example, as well as the pictures, is a great collection of frames, with their own history – hardly less complex and no less fascinating. There is a comparable history of how artists over the centuries have tried to paint abstract ideas, and how they have struggled, in landscapes, to turn a view into a picture. And once painted, what happens to the pictures themselves through time as they fade or get cut into pieces? And how does a public gallery look after them?

These are the kind of subjects and questions the *Pocket Guides* address. Their publication, illustrated in full colour, has been made possible by a generous grant from The Robert Gavron Charitable Trust, to whom we are most grateful. The pleasures of pictures are inexhaustible, and our hope is that these little books point their readers towards new ones, prompt them to come to the Gallery again and again and accompany them on further voyages of discovery.

Neil MacGregor
DIRECTOR

PREFACE

The prime responsibility of the National Gallery is the care of its paintings for future generations. The conservation of the collection is its most important function. At the same time, the Gallery exists to allow everyday access to the achievements of painters of the past, and if that access is impeded by obscuring layers of dirt or yellow varnish then paintings are cleaned. Changes in the appearance of loved and revered works of art always cause strong responses, both favourable and negative, and controversy often follows when great paintings are transformed by cleaning. The aim of this small book is to set out simply the National Gallery's approach to the conservation and restoration of paintings – to describe procedures and to give some idea of why they become necessary. But decisions are always based on the individual needs of pictures and so an account of general principles is followed by a number of individual case-studies.

CONSERVATION
IN THE PAST

The decision in the middle of the nineteenth century to locate and then to keep the National Gallery in Trafalgar Square was to have significant effects on the future conservation of the Collection. From the founding of the Gallery in temporary quarters in Pall Mall there was fierce debate about the wisdom of keeping the nation's pictures in the centre of one of the most polluted cities in the world. Serious consideration was given to removing the collection to the cleaner air of Hyde Park or Kensington Gardens and plans were even drawn up for a grand new building close to the present site of the Royal Albert Hall facing towards the Serpentine.

1. Sir Charles Eastlake.

Atmospheric conditions in the centre of London, the great teeming smoky heart of Empire, are vividly conjured up in the proceedings of the various Parliamentary Select Committees that considered the question: '...the National Gallery is in the vicinity of several large chimneys, particularly those of baths, washhouses... and club-houses...and that connected with the steam-engine by which the fountains in Trafalgar Square are worked, from which great volumes of smoke are emitted...the proximity likewise of Hungerford Stairs and of that part of the Thames to which there is the constant resort of steamboats may aggravate this evil...' [2].

After long deliberation in the 1850s, the decision was made to leave the Gallery where it was, its central location being considered more important than the effects of polluted air on the paintings. A conscious choice was made for public access at the risk of possible deterioration. The significance of this choice was far-reaching, since the necessity of instituting a programme of cleaning and repair was implicit within it.

The paintings were certainly becoming exceptionally dirty. Restorations carried out

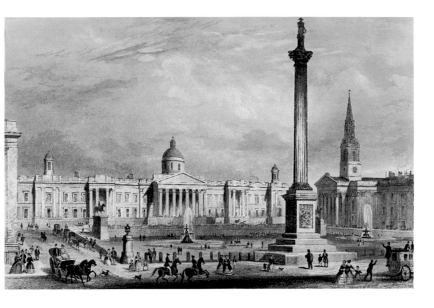

2. The National Gallery in the nineteenth century.

in the early years of the Gallery by the first Keeper, William Seguier, and his brother, John – both picture restorers – had consisted primarily of applying coats of the notorious 'gallery varnish', a golden brown mixture of mastic and boiled linseed oil that remained tacky for a considerable time and therefore quickly became even darker in the dirty London air.

When Sir Charles Eastlake [1] became Keeper in 1844, the cleaning of paintings began in earnest. In 1846 the first five pictures freed from their brown varnishes (including Rubens's *Minerva protects Pax from Mars ('Peace and War')*, Cuyp's *Hilly River Landscape* and Velázquez's *Philip IV hunting Wild Boar*) were shown to an unprepared public. There was immediate outrage. In a famous letter to *The Times*, signed 'Verax', the Rubens was described as 'completely flayed...with characteristic ignorance the rich fine glazings have been scoured off.' The same 1853 Parliamentary Select Committee that considered moving the Gallery to Kensington also looked in great detail at the whole question of picture cleaning. The subsequent report – several hundred pages long – did not commit itself to a judgement on the results of the various cleanings but remarked on the conflicting opinions of 'witnesses whose fervent love of art seems to have kindled some personal animosity.'

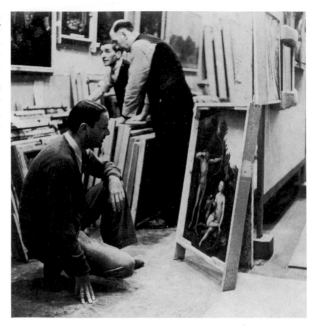

3. Kenneth Clark examining one of the paintings from the National Gallery Collection at Manod quarry, Wales. The pictures were mostly stored here during World War II.

Although Eastlake's name is nowadays largely associated with this first great cleaning controversy, he also established much that we now take for granted in modern conservation. He began the practice of keeping full conservation records for each picture in the Collection – records that are still constantly referred to. He was also actively concerned with what we now call preventive conservation and invited the eminent scientist Michael Faraday to collaborate in producing *A Report on the Protection of Pictures at the National Gallery by Glass*, which concluded by recommending the glazing of pictures as protection against the 'manifold evils' to which they were subjected.

Conservation and restoration of paintings continued under subsequent directors. The Gallery did not employ its own staff for such work until later and used private London restorers in long-established family firms such as those of Morrill or Holder. In 1936 another controversy flared over the cleaning by Holder of Velázquez's *Philip IV of Spain in Brown and Silver*. The critic of *The Daily Telegraph* claimed that 'the beauty of the picture is seriously impaired ... the patina of natural age has disappeared and, I think, the touch of the master along with it ... the upper layer of the work has been destroyed.' More than fifty letters appeared in the

press on the matter and the arguments continued into 1937. Nowadays the painting is considered one of the most beautifully preserved of all seventeenth-century paintings.

During the Second World War, when the National Gallery paintings were mostly in storage in Manod quarry, Wales [3], some seventy were cleaned by nine different restorers, including Helmut Ruhemann, formerly restorer to the Berlin museums, who had come to London in 1933 and was invited by Kenneth Clark in 1934 to be consultant restorer to the Gallery. In 1946 the paintings were seen by the public for the first time in their newly cleaned state. One hundred years and one day after Verax's letter to *The Times* of 1846, another letter to the same newspaper inaugurated a

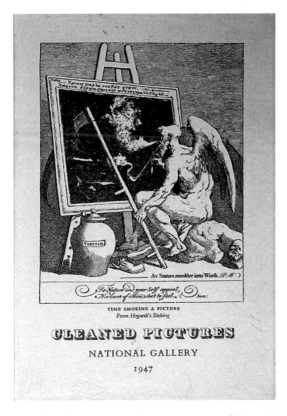

TIME SMOKING A PICTURE
From Hogarth's Etching

CLEANED PICTURES

NATIONAL GALLERY

1947

new but familiar process. Controversy was followed this time by an explanatory exhibition of *Cleaned Pictures* [4] at the National Gallery in 1947, and then the establishment of an international commission under the

4. *Cleaned Pictures*, catalogue of the 1947 exhibition.

9

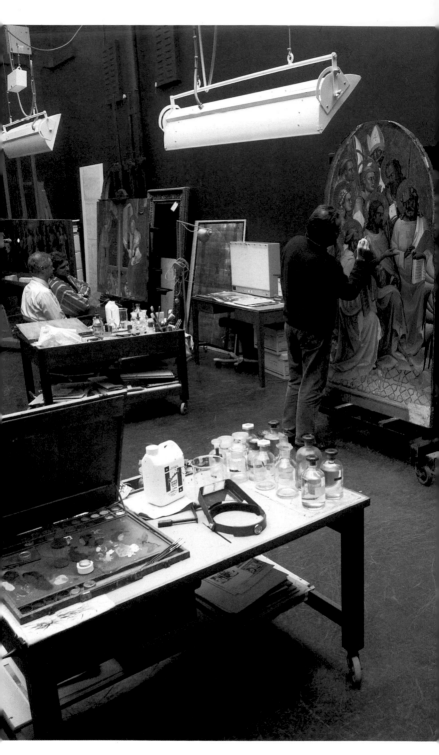

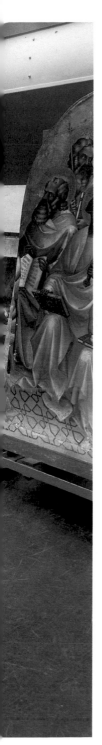

chairmanship of Dr J. Weaver, which concluded that 'no damage was found to have resulted from the recent cleaning.'

The most important result of the Weaver report was to set out clear guidelines for a new Department of Conservation which had been established the previous year. For the first time, the Gallery would employ its own restorers and they would work on paintings inside the building rather than in private London studios. At first, the department operated in unsatisfactory conditions in Room 9 amid constant dust from plaster loosened by war-time bombs. Later, air-conditioned studios located above the exhibition rooms were made as part of the post-war reconstruction programme and were opened in 1960 [5]. In the basement, large workshops were equipped for structural conservation – then a routine and somewhat unconsidered activity, the importance of which was to be considerably reassessed over the next three decades.

The paintings conservation department now employs nine people engaged on the practical treatment and technical examination of paintings. It works in daily collaboration with curatorial, scientific, framing, photographic and exhibition departments in maintaining, studying and displaying the Collection. In recent years, research into European painting techniques has been a growing part of the department's activities – as well as continuing research into the fundamentals of conservation practice. Eastlake's belief that the conservation and restoration of paintings demand a detailed understanding of the painter's methods, materials and intentions remains central to all that the department does.

MATERIALS
AND STRUCTURE
OF PAINTINGS

O f the 2200 or so paintings in the National Gallery collection, the great majority are on wood panel or canvas. Specifying the *support*, the main structural layer, in this way is the principal method of categorising the physical nature of a particular work. Most easel

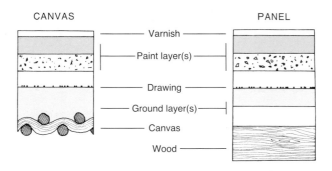

paintings have a broadly similar layered structure [6], and so it is relatively straightforward to devise a form of technical description applicable to works of all periods and types. It will always begin with the support and then work up through the preparation *ground* or *priming*, the *paint layers*, the *varnish* and finally any alterations on the surface of the painting.

Wood panels for painting are usually of species typical of and widely available in their country of origin. Early Italian paintings are almost always on poplar, while northern European panels are often of oak. The working methods of the original panel-makers are sometimes visible. On the back of an untouched poplar panel it may be possible to see the marks of tools such as the adze [7] or, on a seventeenth-century Flemish panel, the unique guild mark of the individual panel-maker [8]. For large panels, several planks are joined edge to edge: the great early Italian altarpieces are made up of massive poplar planks, Holbein's *Ambassadors* consists of ten vertical strips of oak and

Rubens's *Landscape with Het Steen* comprises no fewer than twenty-one pieces of oak of different shapes and sizes. Other woods used for painting include beech, fir and even pine – despite the fact that it makes a rather coarse and unstable support. In the eighteenth and nineteenth centuries imported woods such as mahogany became widely used throughout Europe.

By 'canvas' paintings we mean those on supports of fabric stretched to keep them taut, nowadays over an expandable wooden stretcher [9] but, before the

7. Original adze marks on the back of Crivelli's *Vision of the Blessed Gabriele*, late fifteenth century, photographed in raking light.

8. Panel-maker's guild mark on the back of Peter Paul Rubens's *Portrait of Susanna Lunden*, about 1622.

9. Back of Claude Monet's *Gare St-Lazare*, with colourman's stamp on the canvas and stretcher-maker's stamp on the centre bar.

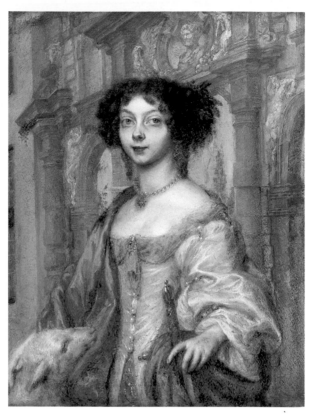

10. Gonzales Coques, *Portrait of a Woman as Saint Agnes*, about 1680, painted on silver.

eighteenth century, over solid wood panels or rigid frameworks called strainers. The fabric is usually linen – although cotton, hemp and silk are sometimes found – and it is usually of plain weave, although the pattern of more elaborate textures such as twill, herringbone and damask can sometimes be seen through the paint. As with panels, it was often necessary to join pieces together to make larger canvases and the seams are sometimes visible.

Other materials have also functioned as painting supports. Copper plates were readily available for print-making and were quite commonly used for small, highly detailed paintings. One painting in the National Gallery is on silver, which gives it a brilliant pale tonality [10]. Vellum, slate, marble, glass, ivory, leather, tin and zinc have also been variously used for painting. In the nineteenth century, commercially prepared supports such as millboard became popular for smaller paintings and *plein-air* (outdoor) sketches.

Wood and canvas supports are, in general, unsuitable for painting on directly since they are too rough and absorbent. Traditionally, they were prepared for painting with layers of *ground* or priming. For panels, this was usually a mixture of gypsum or chalk with animal glue, applied as a thick warm liquid and setting to a rather brittle creamy-white layer which was then scraped and rubbed smooth. For earlier Italian panels this type of ground is called *gesso* (Italian for gypsum). Gesso was also used for late fifteenth- and early sixteenth-century canvases, but it was soon replaced by more flexible preparations of pigments ground in oil, which became the standard form of preparation for canvases up to the twentieth century. The colour of canvas grounds could vary widely – light or dark, warm or cool, all painters had their own preferences. It was a crucial choice because it determined the tonality of the whole painting and, in many cases, it has become more dominant as the painting has aged [11].

11. Nicolas Poussin, *Landscape with a Man killed by a Snake*, 1648, detail, showing the effect of a dark red ground.

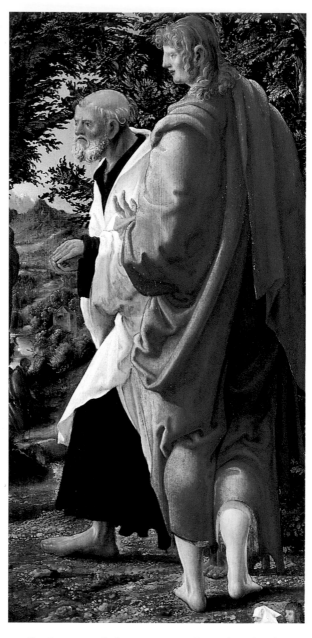

12. Albrecht Altdorfer, *Christ taking Leave of his Mother*, probably 1520, detail.

On the ground, the painter might outline the design to be painted in some kind of underdrawing although this stage was by no means universal. The revelation of spectacular underdrawings by infrared photographic techniques has been one of the most fascinating new developments in the study of painting techniques [12,13].

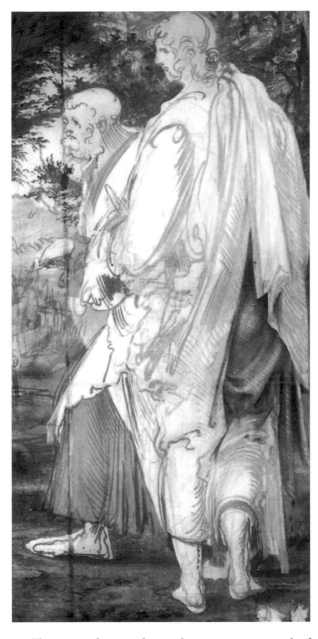

13. Infrared reflectogram assembly of detail shown in 12, revealing underdrawing.

The paint layers themselves are composed of coloured pigments mixed with a binding medium such as egg or a drying oil such as linseed oil. They can vary enormously in thickness and complexity, from thin transparent washes (*glazes*) to thick opaque textured brushwork (*impasto*). Pigments have been derived from

a wide variety of sources – naturally occurring minerals (such as cinnabar, lapis lazuli, azurite and malachite), organic plant and animal products (madders, carmines, Indian yellow) or synthetic manufacture by chemical processes (lead white, lead-tin yellow, prussian blue and chrome or cadmium colours). The appearance of a painting is clearly determined by the pigments available to a painter, but the type of medium used also has a major influence on the way a paint surface looks. Oil tends to saturate pigments, making them rich, dark and glossy, while egg leaves them less saturated, more luminous and pale.

One medium that is both optically and physically delicate is the glue (or size) that Dieric Bouts used to paint his *Entombment* in the 1450s [14]. This binder hardly wets the pigment particles at all and the paint is dry, chalky and very pale. The result is an extremely fragile and vulnerable surface – permanently water-soluble and never varnished – and it is therefore kept under protective glass.

In many paintings the paint layers are protected and the colours are given clarity and depth of saturation by a layer of clear varnish. Varnishes, consisting of natural or synthetic resins, invariably discolour with time and this is one of the reasons why pictures are cleaned. Some paintings, such as glue-tempera paintings like Bouts's *Entombment* and certain Impressionist or Cubist works, were never intended to be varnished and are irreversibly altered if they do undergo subsequent varnishing.

CHANGE AND
DETERIORATION

All paintings begin to change from the moment the painter finishes work on them. The effects of natural aging, light, heat and humidity, accidental damage and the sometimes necessary but frequently unwelcome attentions of owners, collectors and restorers all take their toll.

Natural aging is intrinsic to the materials of the painting. Pigments fade or change colour, the medium

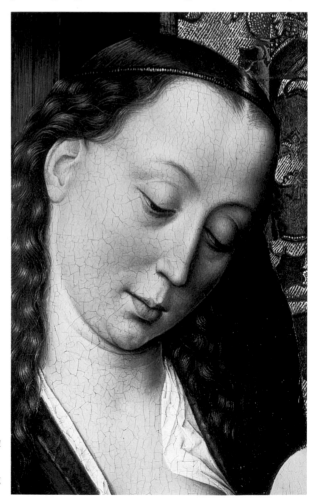

15. Dieric Bouts, *The Virgin and Child*, about 1460, detail showing craquelure.

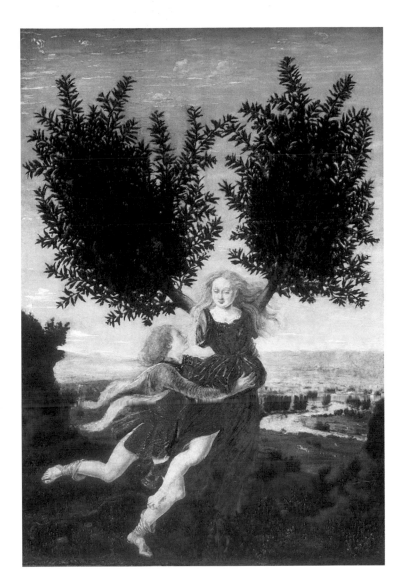

changes character and renders the paint more transparent, crack patterns *(craquelure)* develop as the paint dries, contracts and moves with the support [15]. Some of these alterations are obvious, some more subtle.

In many earlier Italian paintings, the rich, green pigment copper resinate has changed under the effect of light to a deep brown or even black. A notable example is the small *Apollo and Daphne* by Antonio del Pollaiuolo [16], in which the laurel tree and the landscape have both become very dark. The fading of pigments is not

16. Antonio del Pollaiuolo, *Apollo and Daphne*, probably 1470–80.

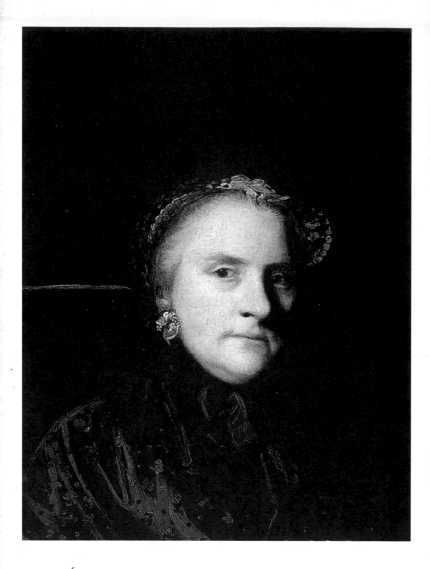

17. Joshua Reynolds, *Anne, Countess of Albemarle*, 1759–60?, detail.

18. Jan van Huysum, *Flowers in a Terracotta Vase*, 1736, detail.

uncommon. Typical examples are the deathly white complexion of Reynolds's *Anne, Countess of Albemarle* [17], in which a pink tone has faded, and the blue foliage of van Huysum's *Flowers in a Terracotta Vase*, from which a yellow has disappeared through the effect of light [18].

Changes in the paint medium that make it more transparent allow features in the underlayers of paintings to show which were not originally intended to be seen. Often, *pentimenti* (literally, *repentances*), where a painter has altered part of a composition by painting

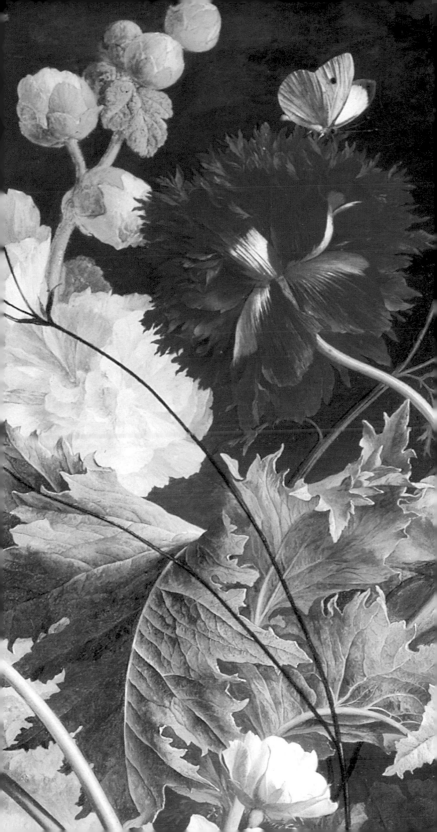

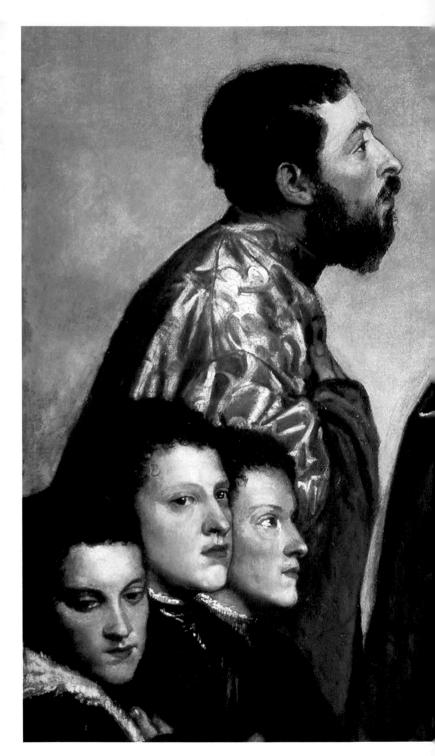

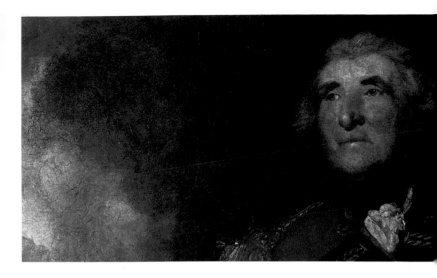

over it, can become visible in this way. One clear example is the repositioned head of the young, bearded man at the left edge of Titian's *Vendramin Family* [19].

The craquelure is also a distinctive feature of many paintings. It can take two main forms: drying cracks – wide fissures caused by slow or faulty drying of the paint – and age or mechanical cracks which develop from the movement of the paint once it is hard and brittle. A notorious example of drying cracks is Reynolds's *Lord Heathfield* in which the painter has used a bitumen-based paint that contracted and split into rough islands as it gradually hardened [20]. The altogether more delicate web of age craquelure can be seen on many paintings in the Collection [15].

Changes to paintings that might be described as deterioration occur because of bad hanging or storage, neglect, accident, vandalism and misguided treatment by past and present generations. Very few paintings have survived unscathed. They have usually been drawn into an inexorable cycle of damage and treatment as the centuries passed. It is now clear that much past remedial treatment by restorers – usually well-intentioned, sometimes unwise, occasionally incompetent – has contributed to the deterioration of works of art of all kinds. The modern restorer/conservator has to deal with a confused legacy of natural change, neglect, past repair and unnatural alteration, examples of which are detailed in the following pages.

19 (opposite). Titian, *The Vendramin Family*, 1543–7, detail.

20. Joshua Reynolds, *Lord Heathfield*, 1787, detail.

RESTORATION
VERSUS
CONSERVATION

The concept of *restoration* has always been somewhat dubious, since it implies returning a painting to its original state – something that cannot realistically be claimed. In the past, it was a term that included all kinds of repairs to damaged paintings – the mending of broken panels and torn canvases, the fixing of flaking paint, the cleaning away of yellow varnishes, the filling of holes and the retouching of missing passages. It became an activity that was deplored when it apparently went too far – when original paint seemed to be scoured away, when retouching of losses turned into wholesale repainting, when compositions were completely altered to suit notions of contemporary taste.

Nowadays, the emphasis is on *conservation*, the preservation of paintings by means that do not necessarily involve active treatment. This approach is described in more detail later. The main purpose of the Gallery's Conservation Department [21] is to prevent deterioration: to maintain the status quo. Much of its work is routine and often unnoticed, but nevertheless

21. The National Gallery Conservation Workshop.

22. The National Gallery Scientific Department.

vital. Every picture in the Collection is inspected regularly and notes of condition made; problem pictures are watched constantly. As a result of routine inspections many minor problems are solved before they become major ones. Flaking or blistering paint, cracks in panels and canvas distortions are examples of the type of defect that must be remedied quickly if permanent loss or damage is to be avoided. Attention to such problems is the everyday, unremarkable, essential work of the Conservation Department.

At the same time, paintings do become obscured by discoloured varnishes, and many still have repaints from previous restorations that conceal original paint and which can seriously mislead. Therefore a gradual programme of cleaning is being followed and it is in this specific context that we now apply the term restoration. Strictly, it now means the recovery of the original paint surface from beneath old varnishes and repaints and the careful retouching of missing areas. Some would define it even more narrowly as the latter stage alone.

The processes of conservation and restoration demand a deep understanding of the original materials and processes used by painters. Much research into the fundamental materials of paintings and into conservation processes is carried out in collaboration with the National Gallery Scientific Department [22] and with colleagues in museums worldwide.

MODERN METHODS
OF CONSERVATION

The main priority of present-day conservators is to ensure the long-term stability of the works of art in their care. The most important way of doing this is to control the surrounding environmental conditions, keeping light, temperature and humidity at steady levels appropriate to the types of materials the artist used [23]. At the same time, safe methods of display and storage protect against accidental damage: for example, particularly fragile or vulnerable paintings are usually exhibited behind inconspicuous, low-reflecting glass.

23. Monitoring the environment in the National Gallery exhibition rooms.

These ways of preserving paintings are passive – they prevent things happening that might cause deterioration. The term *preventive conservation* is used to describe this sort of approach and it forms the basis of everything a modern conservator does. In an ideal world, paintings would be kept stable by preventive conservation measures alone but, unfortunately, many are made of inherently unstable materials or have deteriorated in the past from neglect or mistreatment. Conservators therefore sometimes have to intervene and carry out structural treatment on paintings in order to repair or stabilise them.

The key layer of any painting, usually invisible to Gallery visitors, is the support, the main structural element. Only if the support is sound can the pictorial

layers remain intact. Over the years, many remedies for treating damaged or deteriorated panels and canvases have been devised, some of which were sensitive and sympathetic, some drastic and even disastrous. The modern approach is to do as little as possible: if a painting can safely be left alone, nothing is done to it. This is a quite different philosophy from that of the nineteenth or earlier twentieth centuries, when canvases and panels were routinely subjected to major structural treatments, whether or not they needed them.

PANELS

The most common problems of wood panels are warping across the grain, splitting along the grain, the breaking apart of joins and the loss of paint through cracking, flaking and blistering. As ever, these problems are often compounded by treaments carried out by previous generations of restorers.

Warping is caused by the fact that the back of a panel gains and loses moisture more readily than the front, which is sealed by the paint layers. Repeated swelling and shrinkage of the exposed wood can lead to a permanent compression of the wood cells on the back face and the consequent warping of the panel with the paint on the convex side. This can be corrected temporarily by exposure of the back to high humidity, but will recur as the latter dries out. Nowadays, slightly curved panels are considered acceptable but in the past fierce restraints were applied in order to keep them flat and these have done a great deal of harm. Heavy wood or metal battens were often attached to the back of a panel [24], but as it tried to move with fluctuating humidity it would strain against the much stronger battens and break apart – either at a join or, more seriously, along a weakness in the wood grain.

Even worse were the practices of thinning (reducing the thickness of a panel by shaving away wood from the back) and cradling. A cradle is a grid-like framework consisting of fixed bars glued to the back of the panel parallel to the wood grain, with free-running cross-pieces passing through slots cut in them. In theory, the panel can expand or contract across the grain while the warp is controlled but, in practice, the

24. Wooden battens formerly attached to the back of Botticini's, *Assumption of the Virgin*.

cross-pieces often become jammed. The panel is then liable to corrugate and crack along the line of each fixed bar, especially if – as is often the case – it was thinned before the cradle was applied. The paradox of this type of treatment is that, if a cradle functions correctly, the panel was probably strong and stable enough not to need it in the first place.

Present-day practice is to leave panels as unrestrained as possible. Where battens or cradles are not actually causing harm they can be left alone but, if there is obvious strain in the panel, they are removed by careful sawing and chipping with sharp chisels [25]. If a panel is strong enough to support itself, it can simply be framed and displayed as it is, but for weak panels, perhaps weakened further by past thinning, some kind of secondary support is necessary. Commonly these days this takes the form of a tray, a cushioned backboard which holds the panel unobtrusively at the edges with flexible pads: this system allows movement and at the same time protects the back of the panel from sudden fluctuations in humidity.

The mending of splits or joins that have come apart is sometimes necessary. Occasionally, badly mended joins might have to be re-broken to align them properly. To help with accurate alignment of splits and joins, a panel-joining table [26] is used by Gallery conservators: this provides horizontal pressure on the edges of the panel to push the sides of the split or join together while the adhesive is setting, together with vertical pressure from above and below to keep both sides in register.

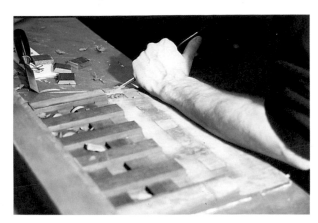

25. Removal of a cradle.

26. Panel-joining table.

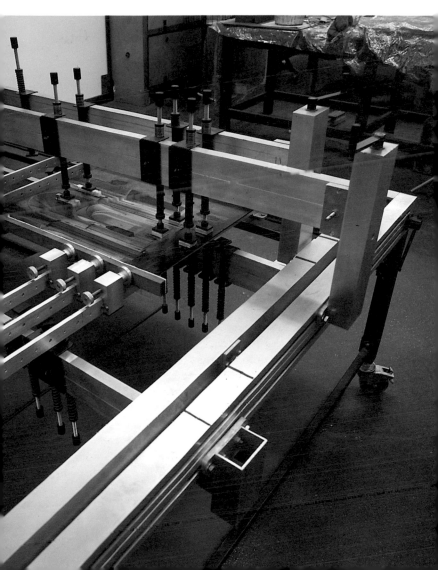

27. Re-attachment of loose paint. One of the most common problems of panel paintings (and of canvas paintings too) is flaking or blistering paint caused by movement of the support. Re-attachment of loose paint using adhesives and heated spatulas is a routine operation in any conservation studio [27].

CANVASES

Canvas is a more vulnerable support than wood, easily torn or dented by impact, and also sensitive to humidity, sagging or tightening as the weather changes. As it ages, it becomes more fragile as the fibres lose their flexibility and can even in extreme cases disintegrate.

To deal with torn, distorted or simply weak canvases, the standard treatment has been – and often still is – lining, in which the painting is taken off its stretcher, mounted on a second canvas and then re-stretched. This process of reinforcement gives strength, corrects distortions and sticks down the edges of tears and holes. Moreover, the adhesive used to attach the new lining can be made to penetrate through the original canvas to secure any flaking paint from behind. When a first lining eventually in its turn becomes old and perished it is taken off and replaced with a new one – the process of relining.

The traditional method of attaching a lining was to use animal glues and hot tailors' irons. Expertly done, this alarming technique could achieve satisfactory results. However, the old methods could also do much harm by scorching, crushing and scraping the paint layers. A good deal of the damage to paintings uncovered by today's restorers and blamed on over-cleaning was, in fact, caused by past liners and subsequently concealed by repaint and discoloured varnish.

Another problematic aspect of lining is the choice of adhesive. Whereas water-based animal glues worked well for most paintings, occasionally and unpredictably they would cause disastrous shrinkage of the canvas. To avoid this, wax-based adhesives were introduced as a safer alternative: however, they were less effective at correcting deformations in paint and canvas and had the added disadvantage of severely darkening some types of painting [28].

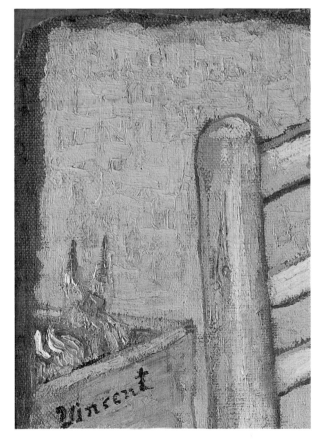

28. Detail of *Van Gogh's Chair*, 1888. Exposed canvas around edges darkened by wax lining.

In the past, the lining of canvas paintings was an almost automatic stage in the restoration process – whether or not it was necessary. Very few pre-nineteenth-century paintings have escaped. Works in the National Gallery collection that have remained unlined include Moroni's *Canon Ludovico di Terzi*, *The Brazen Serpent* [29] and *Moses striking the Rock* by Giaquinto, and Velázquez's *Philip IV of Spain in Brown and Silver* [30]. The freshness and precision of their paint surfaces is striking. A number of nineteenth-century paintings,

29 (opposite). Corrado Giaquinto, *The Brazen Serpent*, 1743–4, detail.

30. Diego Velázquez, *Philip IV of Spain in Brown and Silver*, about 1631–2, detail.

including key Impressionist works such as Monet's *Gare St-Lazare*, Renoir *At the Theatre* and Morisot's *Summer's Day* [31] are also unlined. Nowadays the integrity and undisturbed textures of unlined paintings are much prized and the unnecessary and indiscriminate lining of many paintings is a cause for regret. Especially serious was the wax treatment of many Impressionist and Cubist works in collections all over the world, their dry, pale tonalities now irretrievably darkened, their delicate opacity now greasy and transparent.

Despite all these reservations, lining is still occasionally required – for example, in the case of badly torn paintings – and relining of previously lined but now deteriorated canvases is sometimes inevitable. In some studios it is still carried out safely by highly skilled practitioners using hand-irons but, increasingly, low-pressure suction tables such as that in use here at the Gallery are employed [32]. A painting is held by gentle suction against the minutely perforated surface while precise applications of heat, humidity and pressure are made, either to the whole canvas or to small areas. The control possible with tables such as these and the

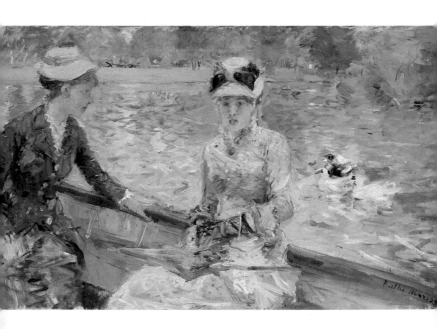

availability of new formulations of lining adhesive allows the attachment of linings with minimal pressure and virtually no penetration of adhesive: canvases can, therefore, be reinforced where necessary without any of the drawbacks of traditional methods.

Lining used to be the universal panacea for any defect found in canvas paintings but, in tune with the present-day philosophy of minimal intervention, they are now treated only for what is actually wrong with them. Many canvases can be treated without lining. Dents or distortions can be corrected by gentle pressure with controlled heat and humidity. Small holes and tears and weak tacking edges (the margins of the canvas turned around and tacked to the stretcher edges) which tear away from the stretcher are strengthened with almost invisible gossamer-like fabrics. Flaking paint can be treated locally by the standard methods of blister treatment used for panels. The suction table is particularly useful for introducing small quantities of adhesive into fragile paint surfaces: one such treatment that would have been impossible by any other method was the painstaking consolidation of Van Gogh's exceptionally delicate unlined *Wheatfield with Cypresses* (p.58).

32. Low-pressure suction table. The dome permits humidity to be applied to the front or back of the painting.

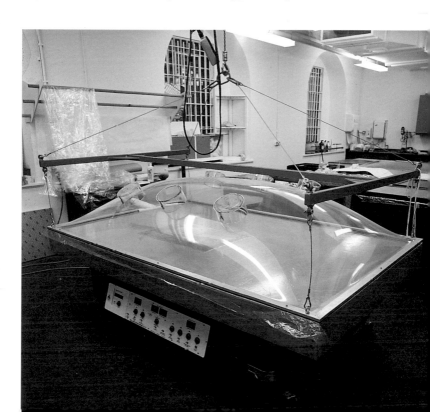

APPROACHES TO CLEANING AND RESTORATION

The cleaning of a painting is usually defined as the removal of dirt, discoloured varnish layers and non-original repaints from its surface. Such a definition seems straightforward enough but, because strik-

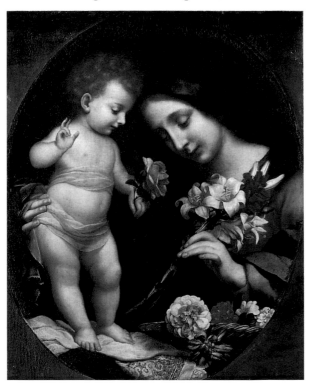

33. Carlo Dolci, *The Virgin and Child with Flowers*, 1650–86, before cleaning.

ing changes of colour and occasional alterations of detail may result, it has often been an area of intense debate and even controversy as long-familiar images take on new appearances [33, 34].

How – or whether – a painting is cleaned depends on the nature of the painting itself, its past history and the aesthetic objectives of those responsible for the cleaning. As with conservation treatments, every case is examined individually and a unique assessment made

of condition and the likely consequences of cleaning. Before any treatment proceeds, a balanced appraisal of the advantages and disadvantages is made by curators and restorers, informed where necessary by the results of technical examination. Is cleaning necessary? Can it be done safely? Is the painting too damaged under those layers of repaint? Is it better to preserve the restoration of the past than to attempt our own? Such questions as these are always discussed. The final decision is made by the Trustees of the National Gallery on the advice of the Director and, in some cases, it is decided that cleaning should not be attempted.

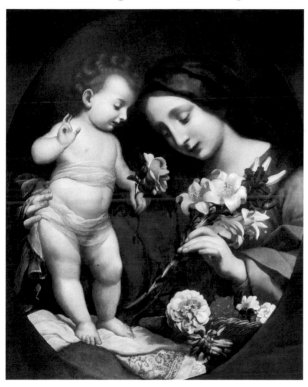

34. Carlo Dolci, *The Virgin and Child with Flowers*, 1650–86, after cleaning.

Cleaning might be ruled out for a variety of reasons. For some paintings that were extensively damaged and repainted in previous centuries, cleaning could result in a severely fragmented image that is, in its way, as misleading as the restoration that now conceals it. Gentile Bellini's *Sultan Mehmet II* [43] is a notable example of a famous image too damaged to clean and Pisanello's *Virgin and Child with Saint George and Saint Anthony Abbot* [45] is of uncertain status, having been

recorded, while in Eastlake's collection, as 'rubbed to the ground' in places and repainted for him by the Milanese restorer Molteni.

Other paintings cannot be cleaned for technical reasons. Some artists incorporated waxes or resins into their paints which might be soluble in the kinds of solvents used for cleaning. In the eighteenth and nineteenth centuries especially, the abandonment of traditional workshop practice led to experimentation with unstable and impermanent artists' materials which can make cleaning hazardous, if not impossible. Some of the panels of George Stubbs [52] were painted in a soapy wax medium, still soluble in the mildest of cleaning solvents.

When cleaning is decided upon, it can proceed through several stages. First, accumulations of grey dirt and grime are removed from the surface. Even this simple procedure can result in a spectacular recovery

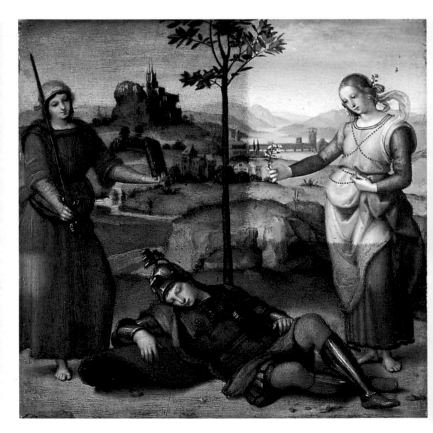

of the original colours, such as that seen in the tiny 'Vision of a Knight' by Raphael [35], or the large *Bathers at Asnières* by Seurat [36].

Removal of surface dirt may be all that is required. Usually, however, there are layers of resin varnish that have discoloured, leading to an overall yellowing and darkening of the image. In the nineteenth and early twentieth centuries, artificial toning was sometimes incorporated to give varnishes the 'golden glow' that was then so much admired. There may also be dirt between successive varnish layers if the painting has been revarnished more than once.

Removal of darkened varnishes is a delicate and painstaking process, carried out with small amounts of solvent on cotton wool swabs [37]. Clearly, it is an operation that cannot allow the smallest margin of error. The solvents chosen must be capable of softening the varnish but not the original paint. Solvent theory

36. Georges Seurat, *Bathers at Asnières*, 1884. dirt layer partly removed, detail.

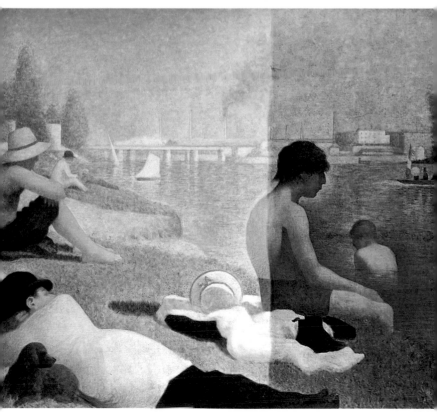

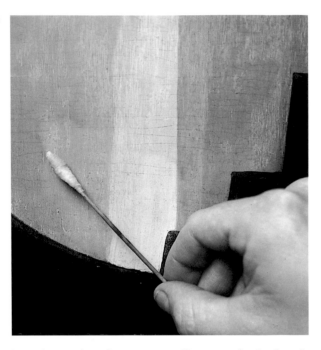

37. Cleaning in progress.

has shown that there is a small group of volatile solvents that will readily dissolve natural resin varnishes but not dried oil paint, and these are the materials that are generally used for cleaning paintings. Nevertheless, constant examination on a microscopic scale is necessary to be aware of variations in the painter's technique that might require a cleaning method to be modified. In the past, the use of abrasive cleaners, powerful solvents or strong chemical reagents has commonly caused the erosion of some paint surfaces, leaving them thin and worn. It is now possible to check, by sensitive forms of chemical analysis, whether the vulnerable components of a paint film remain intact through the cleaning process. Cleaning does not proceed if there is any danger of removing original material.

Discoloured varnishes affect the colours of a painting unevenly. Because they are generally yellowish-brown, they reinforce warm tones but counteract cooler blues, greens and whites. Moreover, they are often slightly cloudy and this has the effect of not only darkening the lights but also lightening the darks, diminishing the tonal range of a painting. Removal of old varnishes, therefore, can have a dramatic effect on the overall colour, balance and depth of a composition [38].

In some cases, even the presence of a clear varnish can distort the painter's original intentions: the Impressionists and Cubists often chose to leave the surfaces of their paintings dry and unsaturated and, unfortunately, many of their works have been irreversibly changed by later varnishing.

Varnish removal may not complete the cleaning process, since paintings have often been retouched to conceal past damages and losses or repainted in parts to alter the composition. The conservator must then distinguish between original and non-original material and arrive at a rational judgement about whether to remove some or all of the later paint. This may be done with the same solvents used for varnish removal or may require gentle scraping with scalpels under a microscope. It is usually worthwhile removing old retouchings since they often cover large amounts of perfectly well-preserved paint around the damages they were put on to conceal.

Cleaning may involve all these stages but it is important to realise that there is no absolute level to which a painting has to be cleaned. Quite different

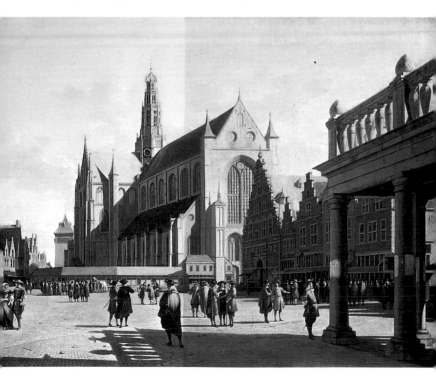

degrees of dirt, varnish and repaint removal may be appropriate for different paintings. Although cleaning is sometimes necessary for the purposes of conservation treatment (p.72), it is undertaken primarily for aesthetic reasons and different aesthetic decisions can be equally valid as long as they can be achieved safely – but, of course, the end results may look very different. As the Italian restorer Cesare Brandi wrote thirty years ago, 'every cleaning is an act of critical interpretation.'

Nevertheless, in many instances it is possible and desirable to proceed through all the stages of cleaning and reveal unobscured original paint. A cleaned painting can be in almost perfect condition, or can look distinctly alarming with all its old damages showing [39].

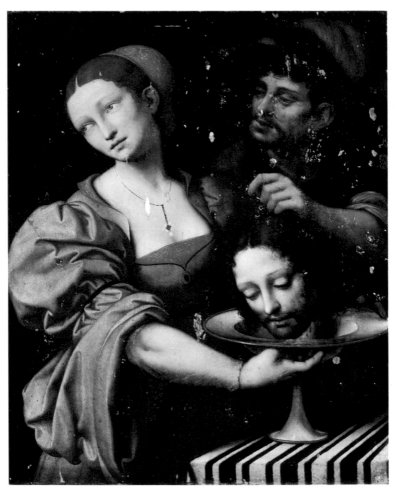

Paint may also be original but not have its original appearance: pigments may have changed colour or faded, or increased transparency of the paint may reveal underlayers not originally visible.

40. Showing 39 after restoration.

The conservator then has another aesthetic decision to make: how much restoration should be done – that is, how much of the old damage should be concealed by new retouching? Cleaning decisions certainly determine the way a painting looks, but so too does the approach to restoration. Restoration has to balance two conflicting requirements – those of legibility and authenticity. On the one hand, an observer wishes to see a composition uninterrupted by damage and loss; but, on the other, it is necessary to know which parts are original paint and

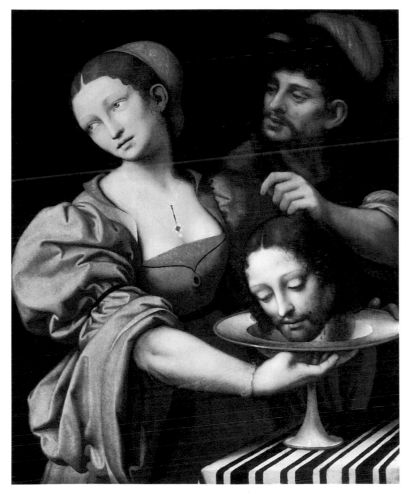

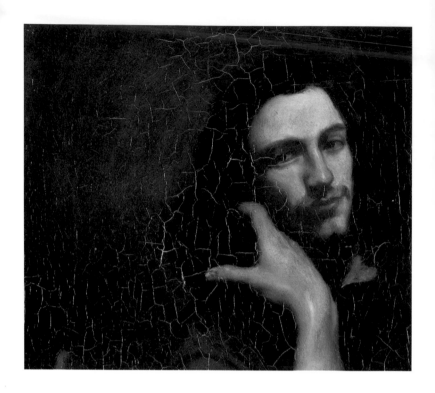

41. Gustave Courbet, *Self Portrait*, 1845–50, after cleaning, before restoration, detail.

which are not. These two requirements are usually satisfied by insisting on a full photographic record of the true condition of a cleaned work, followed by restoration. All restoration is a compromise, attempting to diminish the impact of disruptive losses while allowing a painting to appear gracefully old. For example, craquelure, a signifier of age, is not normally retouched: we expect an old paint film to be cracked and it is not usually disturbing. Only where wide, white shrinkage cracks arise from a technical failure of the paint medium might a small amount of retouching be acceptable [41, 42].

If it is decided to make good old paint losses, they are first filled with a putty, textured to match the surrounding paint surface. Retouching (or inpainting) is then carried out over the filling, taking care not to encroach on to the adjacent original paint. Normally the attempt is made to reconstruct as fully as possible the missing parts of a composition within the outlines of the damage – continuing the design and matching colours as completely as these can reasonably be inferred [40]. If, however, it is not possible or not

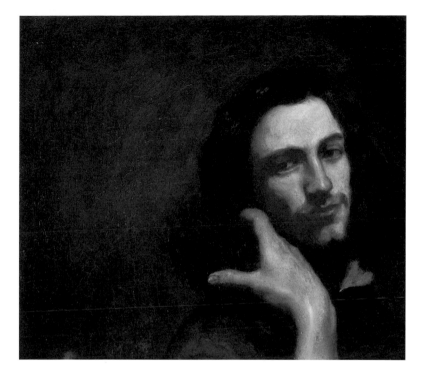

thought appropriate to carry out deceptive retouching, then some sort of visually distinct inpainting can be done. This could be a single unobtrusive colour (a so-called 'neutral tone') or a partial reconstruction in which the pattern of the retouching is left plainly evident. Three panels from Duccio's *Maestà* in the National Gallery collection demonstrate some forms of visible retouching (pp.68–71).

Whatever type of retouching is chosen, the new paint used should be stable, should discolour as little as possible and should remain easily removable in solvents that will not affect the original paint. In practice, either watercolours or synthetic resin paints are used; oil paint is not satisfactory for inpainting as it discolours and becomes very hard. The final stage of the restoration is to apply a clear varnish over the painting – except, of course, in those cases where the surface should be left unvarnished. A picture varnish should be stable and reversible, ensuring that cleaning will not need to be repeated for a long time and that, if it does eventually become necessary, it can be achieved with the least possible intervention.

42. Showing 41, after cleaning and restoration.

SOME RESTORATION PROBLEMS EXAMINED

DAMAGE CONCEALED

Attributed to Gentile Bellini,
The Sultan Mehmet II,
1480, oil on canvas

Pisanello,
The Virgin and Child with Saint George and Saint Anthony Abbot,
mid-fifteenth century, tempera on poplar

These two works were acquired within a few years of each other and were restored in Italy by the same celebrated restorer in the 1850s and 1860s.

The Bellini [43] was bought in somewhat obscure circumstances from an old man, said to be the son of an Englishman, in Venice in 1865, by Layard of Nineveh for just £5. The Pisanello was bought by Eastlake from the Costabili collection in Ferrara in 1858. In his diary he noted its condition – the sky 'almost rubbed to the ground' and the armour and dress of Saint George 'once beautifully finished but now almost totally obliterated' – and kept it for his own collection as he considered it too damaged to purchase for the National Gallery. Ultimately it found its way into the collection anyway, since it was presented by Lady Eastlake in her husband's memory in 1867.

The paintings were restored by Giuseppe Molteni, *conservatore* at the Brera, Milan, and Eastlake's preferred restorer abroad. Molteni worked on a number of paintings bought for the Gallery in Italy and, in recent years, investigations of the paintings themselves together with archival evidence have revealed the extent of his 'restorations' on damaged and undamaged pictures alike. It was said of him that he took part in 'the battle to correct the naive inaccuracies of the old masters' and he certainly reworked compositions to conform to his own notions of decorum.

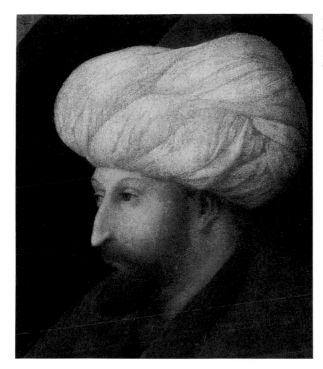

43. Attributed to
Gentile Bellini,
*The Sultan
Mehmet II*, 1480,
detail.

44. X-ray of 43.

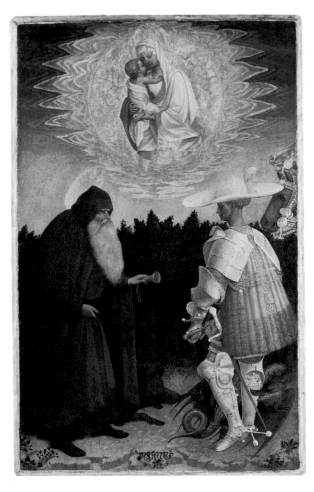

45. Pisanello, *The Virgin and Child with Saint George and Saint Anthony Abbot*, mid-fifteenth century.

We can judge the extent of his work on *Sultan Mehmet II* from a modern X-ray [44], which shows that, under Molteni's repaint, the original painting is a ruin, with large pieces of canvas missing and much of the paint flaked away. The paint that we can see is all Molteni's and as an historical likeness it is almost wholly untrustworthy. Although the restoration and the varnish have darkened, there is no question of cleaning it, since only fragments of the original survive.

The true state of Pisanello's painting [45] is more difficult to judge, but examination under the microscope reveals that Molteni repainted it substantially and that much of the present finish of the picture is

due to him. Indeed, so pleased was Molteni with his work on it that he spoke (jokingly we might guess) of changing his first name from Giuseppe to Vittore, then thought to be Pisanello's. Molteni's paint seems to follow the original design fairly closely; investigations to determine the exact condition of the authentic painting that underlies this famous image will continue but cleaning is not at present contemplated.

PICTURES REMADE TO SUIT CHANGING TASTE

Sassoferrato, *The Virgin and Child Embracing*, 1660–85, oil on canvas

Romanino, *The Nativity*, probably 1525, oil and egg on wood

Documentary and technical evidence have uncovered two intriguing episodes during Eastlake's ambitious campaign of acquiring pictures from Italy in the 1850s and 1860s. Already the target of criticism for the cleaning of paintings at the Gallery, he seems to have taken steps to avoid controversy over Sassoferrato's *Virgin and Child Embracing* [46] that were not detected until the painting was cleaned again in 1986.

During this treatment, the Virgin's blue robe and the green curtain were found to have been extensively overpainted. A cross-section taken from the robe [47] showed the original pale blue paint covered by later layers of varnish, a repaint of cobalt blue (not introduced to the artist's palette until the early nineteenth century) and a layer of brown toning.

The explanation for these added layers is to be found in a memorandum from Eastlake to his Keeper of Paintings, Robert Wornum, dated 16th November 1864, which refers to the arrival of the painting from Venice where it had been bought: 'The Sasso Ferrato may be expected in a few weeks – it will, however, require a little revision and possibly a little patina before it is put up.' In a later note, Eastlake mentions the visit of a restorer, Pinti, who was to varnish the picture only after it had been tried out in the gallery where it was to hang.

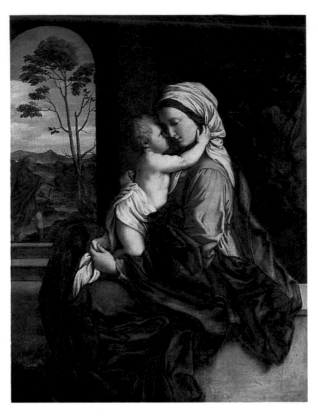

46. Sassoferrato,
*The Virgin and
Child Embracing*,
1660–85,
before cleaning.

47. Cross-section
from the Virgin's
robe before
cleaning, showing
layers of repaint
and toning.

The brown toning found as one of the uppermost layers on the painting is undoubtedly Eastlake's 'patina' and the cobalt blue repaint is, presumably, the 'little revision' that he anticipated. In the 1986 cleaning they were removed [48], revealing once more Sassoferrato's original colours [49]. So brilliant are they that it is not difficult to imagine Eastlake's nervousness at showing his new acquisition to a critical public and his instructions to Pinti to tone the painting down.

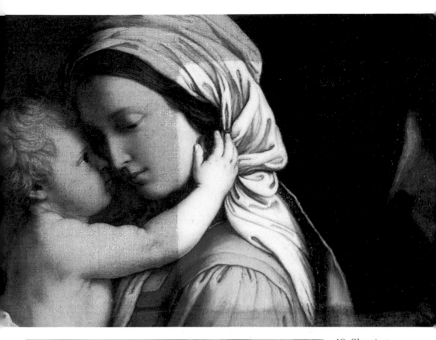

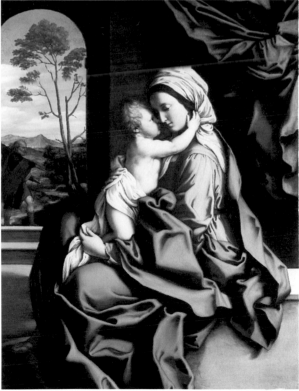

48. Showing detail of 46, partly cleaned.

49. Showing 46, after cleaning.

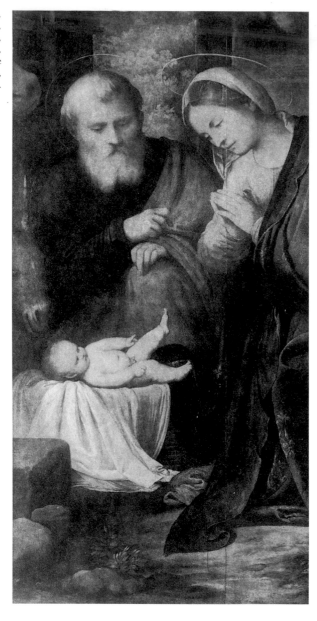

50. Romanino,
The Nativity,
about 1525,
central panel,
detail of the
bottom left,
before cleaning.

Romanino's five-panel altarpiece was bought for the National Gallery in 1857 from the Averoldi family in Brescia for £804. It was restored in Italy by Giuseppe Molteni (see p.48) who seems to have objected to the proximity of an ox's head to the infant Christ: in order to 'improve' the composition he simply

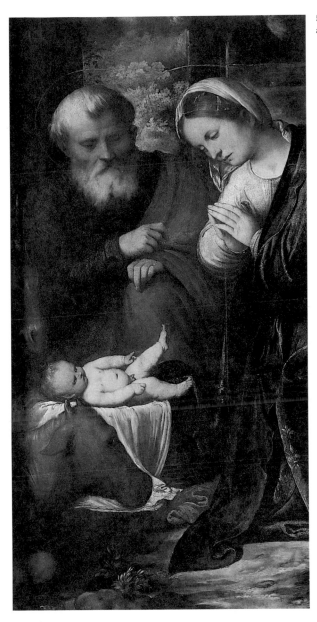

transformed the ox into white drapery and a large stone. Realising, however, that the presence of an ox was essential at the Nativity scene, he introduced the snout of another one to the left of Joseph's head [50]. These overpaints were removed in 1968 to reveal the undamaged original [51].

George Stubbs, *A Lady and a Gentleman in a Phaeton*, 1787, oil and stearine wax on oak

Edgar Degas, *Miss La La at the Cirque Fernando*, 1879, oil on canvas

Neither of these paintings can be cleaned by traditional methods, despite the fact that they have discoloured varnishes that might, in other circumstances, be removed. The varnish on the Stubbs [52] is so yellowed that all the delicate handling of figures, trees and landscape is seen as if through a deep filter and many of the colour subtleties are concealed. The varnish on the Degas [53] is orange-yellow and quite darkened. Cleaning, one might think, would be highly desirable for both pictures – but it has been ruled out, because it cannot be accomplished without the danger of original material being removed.

Microchemical analysis has shown that Stubbs mixed a highly soluble stearine wax into the oil medium he used to paint this picture, presumably because it gave particular handling properties and soft, blurred paint textures that appealed to him. His panel paintings

52. George Stubbs, *A Lady and a Gentleman in a Phaeton*, 1787.

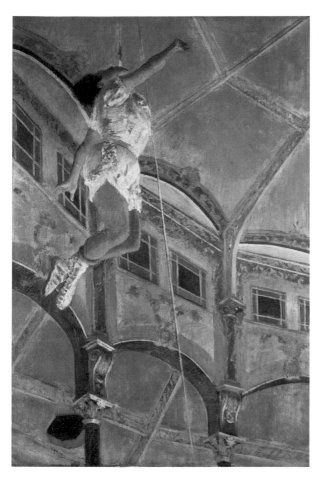

53. Edgar Degas, *Miss La La at the Cirque Fernando*, 1879.

of this period are notorious for their experimental media and for the disasters that have befallen restorers who have tried to clean them. Any solvent strong enough to dissolve the discoloured varnish will also dissolve the paint beneath it. Until scientific research can provide a varnish solvent specific enough to leave the stearine component intact, this particular cleaning will not be contemplated.

Cleaning was started on the Degas, to the extent of removing surface dirt, but was not pursued once a small sample of the varnish had been examined. It was found to contain orange pigment – the dominant colour of the painting itself. It was concluded that Degas (or somebody else) had brushed varnish on the painting before it was properly dry and that some of the orange

paint had become incorporated into the varnish layer. Since the varnish contains original colouring matter, it cannot be removed.

The reasons are different – one because of the artist's chosen paint medium, the other probably a result of premature varnishing – but the result is the same: two paintings that will remain uncleaned.

NO LINING, NO VARNISH

Vincent Van Gogh,
A Wheatfield, with Cypresses, 1889, oil on canvas

Like many of Van Gogh's paintings, *A Wheatfield, with Cypresses* [54] is fragile and vulnerable but, unusually, it has survived in almost perfect state. It has never been lined, consolidated or varnished – all processes that would have altered its original appearance irreversibly. Painted on exceptionally fine canvas with a thin lead-white ground, its technique is dramatically

54. Vincent Van Gogh, *A Wheatfield, with Cypresses*, 1889.

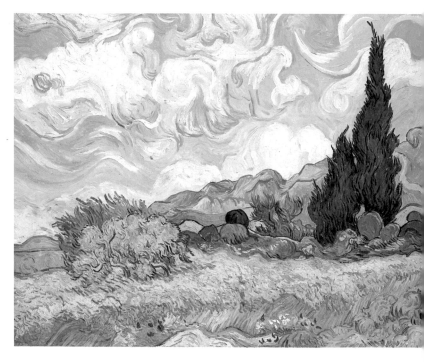

varied, as can be seen in a photograph taken with the light shining through the canvas [55]. Areas of bare, pale ground lie alongside massively thick brushstrokes – some of which have delicate, brittle points, while others bear the flattened impression of another canvas, presumably the result of being stacked behind and pressed against another painting when the paint was still wet. In other parts, there are thinner brushstrokes which, before examination and treatment in 1985–6, were beginning to curl and detach. The painting had also not been cleaned before that date and was covered in grey dirt.

Traditional methods of consolidation for flaking paint were quite unacceptable in this case. In the past, lining or impregnation with adhesives would have been carried out which would have blackened the exposed canvas and ground and endangered the impasto. Unfortunately, many of Van Gogh's paintings through- out the world have been lined – often with wax – and have darkened irretrievably. One example in the National Gallery collection is *Van Gogh's Chair* in which the

55. Showing 54, photographed with transmitted light.

56. Showing 54, on the suction table.

57 (opposite). Showing a detail of 54, partly cleaned.

coarse canvas visible between the brushstrokes and around the edges – originally a pale buff colour – has become a deep brown, caused by saturation with wax [28].

The painting was first cleaned, removing the grey dirt with distilled water and a few drops of pure soap solution, applied in small amounts with soft brushes that did not catch the points of the impasto. The recovery of the original colours was dramatic [57]. The detaching paint was then treated on a specialised low-pressure table, developed in recent years at the National Gallery [56]. With highly controlled suction, warmth and humidity from the reverse, and the use of minute quantities of refined sturgeon's glue, this fragile painting was stabilised in an operation that would have been inconceivable a few years before. It has been left unvarnished, as close to its original appearance as possible. In order to protect the vulnerable surface, it is framed behind low-reflecting glass.

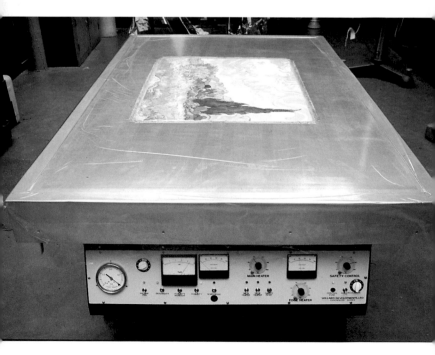

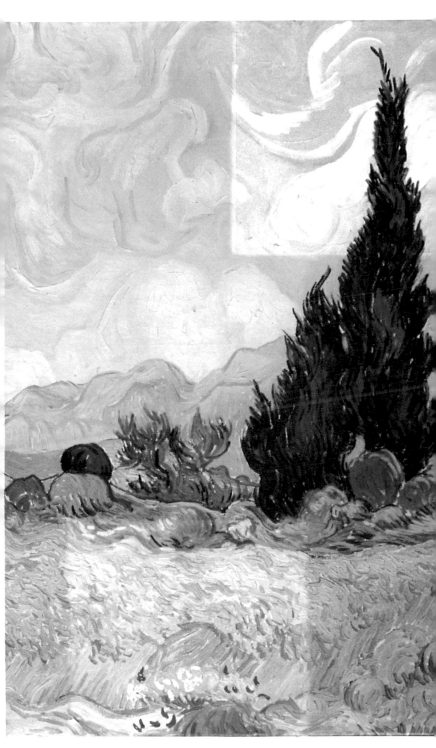

Cima da Conegliano,
The Incredulity of Saint Thomas, about 1502–4,
oil on synthetic panel, transferred from poplar

The treatment of Cima's altarpiece carried out during
the 1970s and 1980s was a rare modern example of
a process that was extensively practised (often unnec-
essarily) in the eighteenth and nineteenth centuries –
the transfer of a painting to a new support. It is nowa-
days carried out only as a last resort, when all other
attempts at treatment have proved unsuccessful.

The painting was commissioned in 1497 by the
Scuola di San Tommaso dei Battuti for their altar in the
church of San Francesco in Portogruaro, to the north of
Venice, and was completed in 1504. From early in its
history it seems to have suffered from flaking paint –
partly, no doubt, through neglect, but probably also
because of some fault in the preparation of the panel.
This condition was considerably worsened when, while
in the Accademia in Venice following restoration treat-
ment in the early 1820s, it was submerged in the
waters of the Grand Canal during a sudden flood tide.

It was bought by the National Gallery in 1870, by
which time its state had become (according to Giovanni
Morelli) 'deplorable', with large areas of loss and repaint.
After its acquisition by the Gallery, deterioration
continued, despite the repeated efforts of numerous
restorers to treat it. Finally, in the 1950s, darkened,
repainted and blistering all over [58], the panel was laid
flat and paper facing stuck over the front to prevent any
more paint being lost.

In the 1970s, further treatment and testing con-
firmed that adhesion between the ground and the panel
had broken down irretrievably in many places and that
the panel itself was too rotten and worm-eaten in some
parts to support the layers above. These observations
led to the conclusion that the painting could only be
saved by the complete removal of the original wood,
followed by mounting on a new support.

The transfer of *The Incredulity of Saint Thomas* is
simple to describe but was extraordinarily long, ardu-
ous and difficult to carry out. The painting was first
freed of as much of its dark brown varnish and dis-
coloured repaints as could be done safely, faced with

58. Cima da Conegliano, *The Incredulity of Saint Thomas*, about 1502–4, before cleaning.

59. Removal of wood.

layers of paper and fabric to protect the painted surface, and secured face-down. Then, in an operation lasting several years, the panel was gradually cut away from the back using sharp hand-held gouges [59]; in

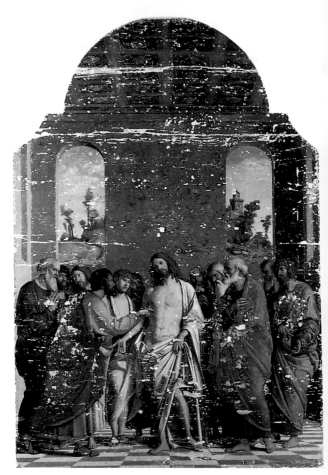

60. Showing 58, after cleaning, before restoration.

61. Detail of a head in 58, with damages and needle holes, after cleaning, before restoration.

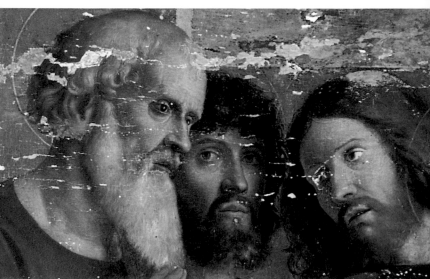

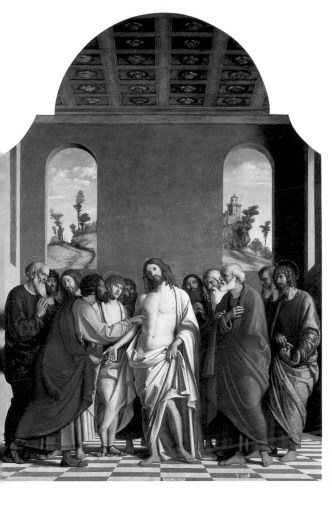

62. Showing 58,
after cleaning and
restoration.

the final stages, as the reverse of the ground was being
exposed, scalpels were used to pare away the last splin-
ters of wood. It was at this point that the strong facing
on the front became vital, because it was the only thing
holding the delicate ground and paint layers together.

When all the wood had been removed, it was possi-
ble to consolidate the ground and paint from the
reverse, prior to mounting them on a sheet of fine linen
on a specially prepared synthetic panel. Finally, the lay-
ers of facing were taken off and the paint surface, now
secure, could be seen for the first time since treatment
had started. The remaining varnish and repaints were
removed and the full extent of the damage sustained
over the previous centuries was revealed [60], including
countless needle holes where restorers had attempted
to inject adhesives in the past [61]. The question now

was how much the image, fragmented by widespread paint losses, should be reintegrated by inpainting.

In view of the illusionistic qualities intended for the altarpiece in its original setting, it was considered essential that the composition should be disrupted as little as possible. Therefore retouchings on the losses were matched as closely as possible to the original colours and forms, using the surviving paint in and around each damage as a guide. In parts that could not be reconstructed with certainty – for example, the embroidered pattern on the hem of Saint Thomas's green robe – retouching aimed at an unobtrusive rendering of form without finishing details.

The restored altarpiece [62] now hangs in the Sainsbury Wing at the end of the principal axis of the Gallery. The structural treatment and restoration that has enabled it to hang there in safety took more than fifteen years to carry out.

THE PROBLEM OF OLD ADDITIONS

Follower of Campin, *The Virgin and Child before a Firescreen*, about 1440, oil on oak panel

Nearly a quarter of this painting [63] is not original. A strip down the right side, which includes the cupboard and chalice, the Virgin's elbow and the right-hand parts of the firescreen and fireplace, was added in the nineteenth century. A narrower addition along the top, containing the upper part of the window with the horizontal window bar, the top of the shutter and parts of the fireplace, was made at the same time. Presumably, these additions replaced parts of the original panel that had been damaged (possibly in a fire) and cut away. However, it is unlikely that the nineteenth century reconstructions of these parts are exact replicas of what was lost, since the structure of the top of the fireplace does not make sense and an old copy after this composition shows a much plainer cupboard and chalice than those now seen here.

When this picture was cleaned in 1992–3, a fundamental decision had to be made. Should the later parts be taken off and the panel exhibited as a fragment? Should they be kept and concealed in some way? Or

should they be retained and left visible? In this case it was decided to preserve the well-known form of the composition in its entirety, including additions, but, in order to allow differentiation between original and later parts, the nineteenth-century paint was made fractionally different in tone at the retouching stage. A casual glance takes in the whole picture, but closer examination enables the additions to be distinguished.

This was a restoration dominated by the aesthetic problem of the additions, but the gain in visual clarity

63. Follower of Campin, *The Virgin and Child before a Firescreen*, about 1440.

and the revelation of the quality of the original paint were the true reasons for cleaning. Hidden beneath more than a century of discoloured varnish and repaint were many telling details of great beauty – subtly coloured firelight catching the near edge of the window shutter and the leg of the stool, blazing points of the fire itself shining through the woven firescreen and tiny drops of milk on the Virgin's breast. Christ's genitals had also been painted out in a more prudish era [64] and were revealed by cleaning.

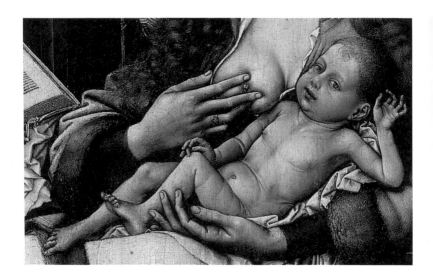

STRATEGIES OF RETOUCHING

Duccio, *Three panels from The Maestà*, 1311,
egg tempera on poplar

These panels all come from Duccio's gigantic double-sided altarpiece, which was carried in triumph from Duccio's workshop to be placed on the high altar of Siena Cathedral in 1311. *The Annunciation* was originally part of the front *predella* (the base of the alterpiece), while *Jesus opens the Eyes of a Man born Blind* and *The Transfiguration* were from the back predella. The altarpiece was removed from the high altar in 1506 and eventually sawn into pieces in 1771. The main sections are still in Siena but some

of the individual scenes from the front predella and most of those from the back predella were dispersed into collections throughout the world. These three found their separate ways into the National Gallery collection at the end of the nineteenth century.

They are, in general, well-preserved, but each of them has specific areas of paint loss that have been retouched in different ways. In each case, some form of visible inpainting has been chosen instead of fully matched deceptive retouching.

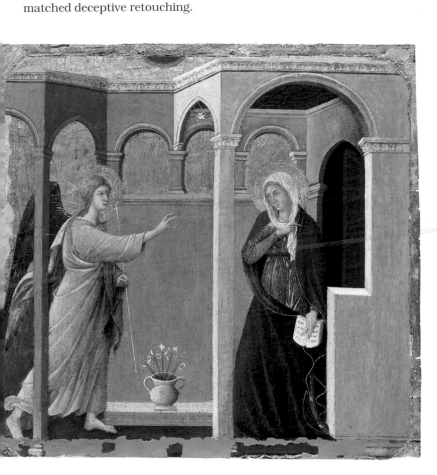

65. Duccio,
The Annunciation,
1311.

The Annunciation [65] has lost paint in strips along the bottom and left sides. At the bottom it is inpainted with a plain grey and at the side the gilding has been imitated in yellow-orange paint. No attempt has been made to reconstruct the missing forms.

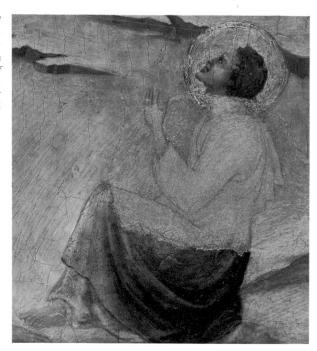

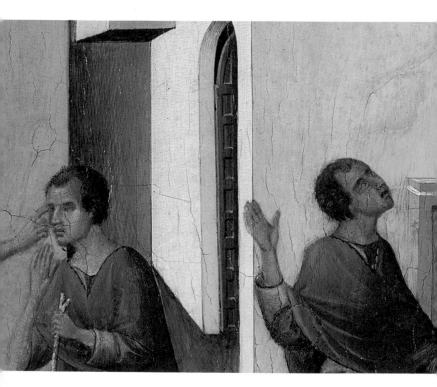

On *The Transfiguration* [66] the entire upper body of Saint John is lost, together with some of the adjacent background. Here the loss has been filled with a pale brown tone and the probable form of the figure has been indicated with drawing lines by the restorer. In addition, the level of the filling in the loss has been left at a slightly lower level than that of the surrounding original paint.

The single major area of damage on *Jesus opens the Eyes of a Man born Blind* [67] is a most crucial one. By cruel irony it occurs at the focus of the entire episode: the face of the cured blind man at the right has flaked away [68]. Here, a more or less deceptive reconstruction was essential in order not to disrupt the narrative power of the scene. Happily, the blind man was depicted twice by Duccio and the face was therefore copied from the same figure shown in the middle of the panel at an earlier stage in the story. However, in order to indicate that this is not original paint, the prominent craquelure visible elsewhere on the picture has not been imitated.

68. Detail of 67, after cleaning, before restoration.

Titian, *Bacchus and Ariadne*, 1522–3, oil on canvas

The cleaning of Titian's *Bacchus and Ariadne* in 1967–8 was undoubtedly the most controversial of any carried out at the National Gallery this century. It is instructive now, three decades on, to consider the issues that determined the actions taken then and to see why this particular cleaning became inevitable.

It is a matter of record that this is a much damaged painting. Disastrously rolled up twice in the first century of its existence, it had a history of constant flaking thereafter and substantial parts of the blue sky were lost. It is also a matter of record that the painting was cleaned to something like its present appearance in 1806–7, as a well-known contemporary enamel copy by Henry Bone confirms. In that restoration the sky and other parts were heavily repainted with oil paint, applied directly on top of the original, and a thick varnish put on. In the next century and a half, the picture continued to flake and each time was retouched and revarnished. By the 1960s the picture was not only dangerously unstable but was covered with layers of thick muddy repaint and deep brown varnish, all of which were cracking, curling and pulling away the paint beneath [69].

An international advisory committee advised urgent action to stabilise the picture and prevent any more paint being lost. In order to secure the flaking paint, all the oil repaints that were covering and blocking the original craquelure had to be removed. This involved removing everything added during and after the 1806–7 cleaning and revealing the brilliant colours seen then and seen again today.

The subsequent controversy centred on a few key issues. Critics asked such questions as: Was the cleaning necessary? Surely Titian could not have intended the colours to be as bright as that? Were original glazes removed or damaged? Even if they were not, original glazes may have been lost or altered in the past – and so was it not likely that the picture now looked very different from its original appearance? In that case, would it not have been advisable to leave a thin veil of discoloured varnish to 'harmonise' a painting now tonally out of balance?

These questions and others have been endlessly debated. The first is straightforwardly answered: cleaning was essential if the deterioration of the painting was to be halted. It is now apparent that the picture was cleaned entirely safely in 1967–8. There is no evidence that original paint was endangered – indeed, close examination shows that there are still traces of old varnish residues on the paint surface. It is undoubtedly the case that cleaning methods of the 1960s were considerably more controlled than those of the 1800s and that paint that had been unaffected by the previous cleaning was unlikely to have been affected by this one.

Our ever-increasing knowledge of sixteenth-century Venetian techniques, of Venice as the centre of the European pigment trade and of Titian's reputation as a supreme colourist tells us that the strong tonality of *Bacchus and Ariadne* is not actually unexpected. There

69. Titian, *Bacchus and Ariadne*, 1522–3, before cleaning.

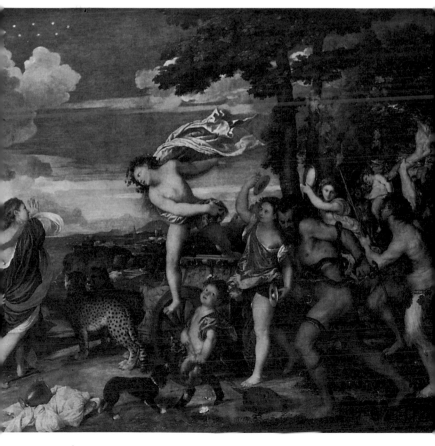

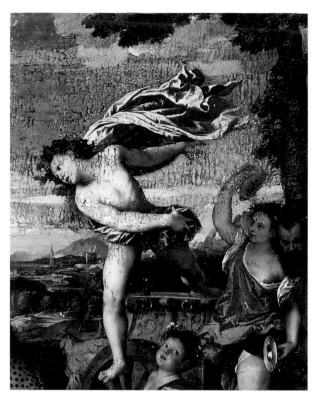

may be minor shifts in colour due to pigment changes, but not enough to unbalance the composition seriously. There is certainly no indication that glazes (which at this date would have been in the same oil medium as the rest of the painting) have been lost, or that the pure ultramarine of the sky that we now see was modified by Titian in any way.

Leaving a thin layer of discoloured varnish over the surface, as some have suggested, was simply not an option in this case, even if it had been thought desirable. The nineteenth-century repaint – brown, disfiguring and, above all, obstructing treatment of the flaking – was lying directly on the original paint surface and had to be removed. The condition of the painting, revealed by cleaning, was very uneven [70]. The foreground, most of the figures and the trees at the right are reasonably well preserved; the sky and the upper part of Bacchus's body are in a poor state, clearly having flaked extensively in vertical lines as a result of rolling. At this stage it was at last possible to secure the loose

paint by impregnation with adhesives both from the front and from the reverse through the canvas support.

Retouching was then carried out to compensate for areas of missing paint. It was decided to use a fully matched technique, eliminating all the damages by comprehensive inpainting [71]. The usual compromise that restoration has to address – between allowing a painting to appear old and battered and wishing for a coherent image – was here resolved in favour of a rather complete reconstruction. Although never articulated in such terms, it may have been the degree of finish – the amount of retouching – that ultimately caused disquiet at the final result. To some eyes, the sky now appears flattened and featureless and this has been mistakenly ascribed to the loss of original glazes during cleaning. But *Bacchus and Ariadne* was not a cleaning problem at all: it was a retouching problem.

71. Showing 69, after cleaning and restoration.

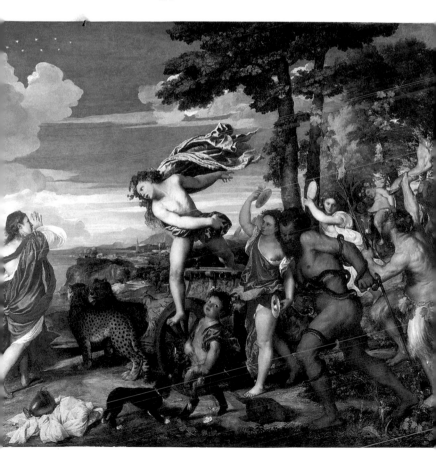

REASSEMBLING THE FRAGMENTS

Pesellino, *The Trinity with Saints*,
1455–60, egg and oil on wood

A bizarre history of dismemberment for predatory collectors, followed by later recovery and reassembly is apparent on even the most casual examination of this altarpiece.

The *Trinity* altarpiece [72] was begun by Pesellino, and finished after his death in 1457 by Filippo Lippi who delivered it in 1460. There is a fascinating set of documents describing the commissioning of the altarpiece for the Compagnia dei Preti in Pistoia and what happened to it when left uncompleted on Pesellino's death. It was taken from Florence to Prato for Filippo Lippi to complete, having been assessed by Lippi and Domenico Veneziano as just half finished. Meanwhile, a

72.Pesellino,
*The Trinity with
Saints*, 1455–60.

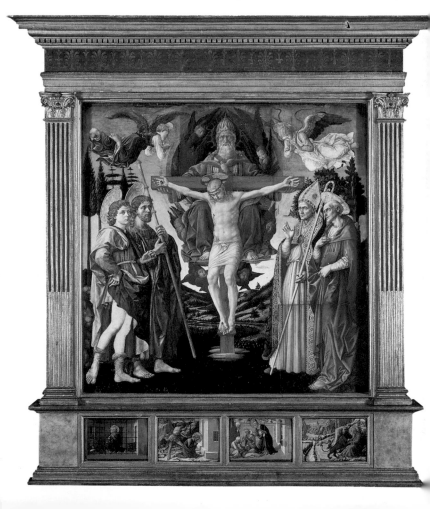

financial dispute was in progress between Pesellino's widow and his business partner, which complicated the final payments made to her for her husband's work on the painting. How much was painted by Pesellino and how much by Filippo Lippi was the subject of disagreement then and has been ever since.

The altarpiece was removed from its church in Pistoia in the eighteenth century and, presumably at that time, the main panel was sawn into five fragments – which, apart from the two angels, one might imagine to be so irregular in shape as to make them unsaleable. Nevertheless they were sold and dispersed.

The *Crucifixion* fragment was purchased in 1863 by the National Gallery. It was clear that it was part of a larger panel and so the hunt was on for the other pieces. Three other fragments were found over the next sixty-five years. Unfortunately, the fourth (depicting the

73. Showing 72, as it was in about 1923.

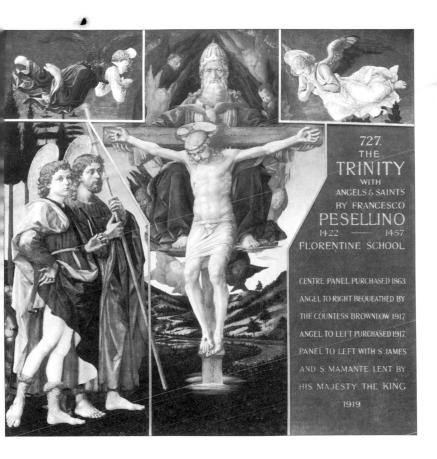

727.
THE
TRINITY
WITH
ANGELS & SAINTS
BY FRANCESCO
PESELLINO
1422 —— 1457
FLORENTINE SCHOOL

CENTRE PANEL PURCHASED 1863
ANGEL TO RIGHT BEQUEATHED BY
THE COUNTESS BROWNLOW 1917
ANGEL TO LEFT PURCHASED 1917
PANEL TO LEFT WITH S JAMES
AND S MAMANTE LENT BY
HIS MAJESTY THE KING
1919

Filippo Lippi,
*Vision of Saint
Augustine*,
1455–60.
Saint Petersburg,
Hermitage.

two saints at the left) was already in the Royal
Collection and not for sale: it was, however, placed on
permanent loan to the Gallery and was reunited with
the other parts in 1919 [72]. The bottom part of the
right hand pair of saints, who were found in 1929, was
never found and a restorer was commissioned to paint
their lower robes and feet.

The *predella* panels (see p.68), also sawn apart in
the eighteenth century, were bequeathed in 1937. But
the final piece of the jigsaw was discovered only in
1995, 132 years after the reassembly began. The pre-
della, now assumed to be entirely by Filippo Lippi and
his workshop rather than by Pesellino, had always
appeared too short for the main panel and any frame it
may have had originally. But then the missing centre
part of the predella was identified – a panel by Filippo
Lippi, *The Vision of Saint Augustine*, now in the
Hermitage, Saint Petersburg [74]. Scholars knew it
existed – some had even remarked on its affinities with
the *Trinity* altar – but nobody had suggested that it was
part of the very same plank as the other predella pan-
els.

FURTHER READING

Articles on the conservation and restoration of paintings appear regularly in the following journals:

The National Gallery Technical Bulletin, London.

Bulletin de l'Institut Royal du Patrimoine Artistique, Brussels.

The Burlington Magazine, London.

The Conservator, United Kingdom Institute for Conservation, London.

Journal of the American Institute for Conservation, Washington D.C.

Kermes: Arte e Tecnica del Restauro, Fiesole, Italy.

OPD Restauro, Opificio delle Pietre Dure e Laboratorio di Restauro, Florence.

Restauro (formerly *Maltechnik-Restauro*), Munich.

Studies in Conservation, International Institute for Conservation, London.

Techne, Laboratoire de recherche des musées de France, Paris.

Zeitschrift für Kunsttechnologie und Konservierung, Worms am Rhein, Germany.